A book with a hole in it

A book with a hole in it

Kamelya Omayma Youssef

Wendy's Subway

This and every place has a hole

in which they are buried
 in which we bury them
 alive and their stories
 enter no bedtime
 moment between a parent and child
a hole in which the parent is buried

a hole in which the child is buried

a hole in which the I is buried
 beneath all the selves it is supposed to be

a hole in which possibility lives

 possible enough to have existed

 a candle brief enough to burn

 a sapling old enough to cast a shadow

 and when it is chopped or uprooted
 it will have lived
 and shaped
 a clearing

 in the forest
 wide enough

 to mark its absence.

"Let's talk about the Arab problem," the title of a brochure distributed by the mayor's office in Dearborn, Michigan, 1985.

I dreamt last night.

I had to tell myself to enjoy and not be afraid of dying.

Then I enjoyed it.

Someone from Dearborn got shot in the head like a bird.

His body at the side of the field.

Everyone accepted it because that's how normal death actually is.

Death is finally real.

I am more afraid of the death of others than the death of myself.

I am not immune to sentimentality.

I am an architect of buildings not inhabited.

It takes me a while to build a perspective.

The person who is not the possessor of power.

Is waiting for knowledge to arrive.

The belated certainty of what happened in a single moment.

Life is full of single moments.

I am here for you.

We waste in the comfort of knowledge.

That a body does indeed heal.

It is a poem that has aged and developed small wrinkles like silk would.

I was seventeen waiting for a man to find in me a love for him to want to keep.

I woke up this morning and found bliss.

The small slivers of sunlight slicing through.

The shadows in my room, on my bed—

It has been a few days.

A flash of sunlight in a room, everyone feels it, even the furniture.

The body of the poet never dies, is immortal.

They stand in a doorway.

There, the poet, beyond the limits of time and space.

That night, in a public, I.

Two conversations, one with the barback and the other with a man named.

The next day when I woke.

Piece together memories of the night.

I was so.

My body.

It was mud in my veins.

Not ever again.

I binge watched shows and fell asleep.

I stayed up til 5 am WhatsApp chatting.

Hope in the world again.

People: they are different than the chemistry you have with them.

Innumerable nights like this.

This litany of lovers with whom I have spent nights dancing,

Arabic: that child running.

Include a space for our native tongue, always a specter already lost.

This cut-like-a-knife English language hostland.

I have been flung across the length of a night, a day, days, weeks, months, years.

That quickening that seems it will never stop.

Is always threatened by the forces that surround it.

I will stay grounded. Ground. Here.

I danced, I talked, I.

I went shopping.

They had the Turkish labne which I got anyways.

And there is my day. My days.

The rejection of the world's energies seems impossible, yeah?

It all lives in the bones, in our skin, yeah? Every bit, every bit of light.

I wonder if any of it, this processing, finds its way into my body as knowledge, maybe as gnosis.

They said.

Look up epistemology on Wikipedia.

Three forms of knowledge.

According to the ancient Greeks.

Doxa is hearsay.

Episteme acquired through reason, like school.

Gnosis is knowledge through experience.

I feel like poems come out of a gnosis.

Yesterday, a lot was an affront.

My body, my English.

My right to be (here or anywhere).

Small lines come.

Where every word cuts.

From my parents, I learned:

Go out of your way to not hurt others.

Place bets on your intelligence.

Connect all things to a greater cause.

Max out a credit card to get to you.

Be an on-call friend.

My food wants to feed everyone.

Enjoy being.

Community.

Freedom and non-judgment.

Where they are in their process.

Know they deserve love.

Even if they use it to heal themselves.

How to take care of one's sibling.

That is enough: to stay alive.

He.

An unbearable guilt.

Escape it.

Being a man.

A child who had power and privilege he did nothing to earn.

The honor, the weight.

The family name.

She.

She probably looked at him and understood. She probably forgave him in advance.

She probably.

She probably.

Preemptive forgiveness.

That bottomless well of love Baba tells me about.

Probably weak, fell in love, felt love was holy, a strike of divine.

She probably.

Thought of all the ways to abort the baby.

Names she wanted to name the baby.

Which sisters or cousins she could confide in.

Tell her mother.

That day too.

For the women in my family.

Without justice or understanding or change.

The men suffer in silence.

The shame that cloaks our voices.

Silence that lives in and among peoples' happy—

The poem is a façade, an edifice, a door you can open to find more doors.

There, in all of them, even when she is invisible.

The long ones are a search for a truth, a making of a land, and inviting others to live there.

Her story, her body, her face.

It feels.

She is the reason I poet.

She, the first reason the world didn't make sense.

At family dinners, I practiced the silence of her name.

The terror of her story.

The fear of my own body, and I.

Something near to her.

Qamar, Shams.

The name of a star.

I feel so far from a history and a knowledge that belongs to me.

Language is the key, but it only opens one door.

In evidence, in experience, what.

Words are separate from what they represent.

Language is occlusion.

No evidence, no proof, nothing to show.

My body and the revelations.

The small neurons of memory that contain me.

I have gotten myself to this very place.

Got here and stay here.

Language as evidence.

Coffee.

A reckoning.

Honoring my thoughts by allowing them to exist.

Not silencing.

Not for others.

They flow into me and not out of me—they create, accumulate, debris in the mind.

In the train station.

Subway ads, every single one—white, white, white, perfect text, aesthetic form, perfect, perfect, white, white, every ad, something about Whiteness,

This is an affront.

We are not asked we are told.

I am read.

It is whiteness that gives my body value in this economy it is Whiteness that wants me to keep this whiteness all to myself.

It is Whiteness that does not believe in giving and having nothing left.

I am always standing next to a white version of me that everyone sees, and I am telling them this is not me I am Kamelya Omayma Abbas Mahmoud Salim Hussein Youssef Nassour.

Lineage, my father's. Hm.

A rattling when someone sees me as white, American White.

What constitutes Whiteness in America.

Before, they were farmers.

My mother got married to escape war but not poverty.

There is a global whiteness to talk about here.

If my family had stayed.

A place where I would be whiter than the Filipina, Bengali, Nigerian, Ethiopian, Egyptian, Syrian domestic workers. I would not be as white as the rich Christian women of Lebanon but I'd be as white as my diamond-trading Muslim cousin.

There is a context.

It is causing.

Mostly my own frustration with the invisibility.

I have felt isolated, alone, targeted, fired by white people, shamed by them, pushed to assimilate culturally by them, talked down to by them.

Maybe it's not me, maybe it's just white culture.

I have never lost myself in whiteness.

I keep coming back.

I watched the sunlight fall through the window.

There was a steeple of light on my floor.

I've known this dude for four days.

I am here to enjoy the joy.

I chastised myself for my small vocabulary.

You can control what the language holds and sometimes language is empty.

Keep the marbles in your pocket. Don't eat the candy all at once.

I gave one to Marwa and gave one to Sahar. I gave one to Basma and one to my date.

This guy, he lets me go go go.

If it's who he is or if it's something else.

Here are my old traumas here to protect me.

I am waiting for the other shoe to drop.

And I am also watching it dangle in the air like a constellation.

He might be the one to help me bring children into this world.

That would be funny, random, nice, lucky.

There's a lot left to learn.

I use all my words to talk myself down from the ledge.

This could be useful.

Maybe Anaïs Nin is Anaïs Nin and Sontag is Sontag and where are an Arab woman's journals for me to page through?

I'm looking for gnosis here but it still feels
like epistemology.

There is a titanium rod in my leg, holding me up, helping
me walk.

A love that drives invention.

This is a result of human ingenuity and good guesses
and love.

What drives commodification of the invention is something else, something evil-er.

My grandfather thought up video chat in 1937 when the British brought a telephone to the village. He did not consider commodification.

Another problem to solve with a book.

I am remembering.

I was given writing lessons by my regional manager and executive director.

They told me to compress. To write against time.

I feel like I've forgotten excess since being in the MFA.

I used to think about excess daily.

The sun fills a room with oughtness.

I cannot trust my instinct to love.

With others, I get lost.

Sunday evening, Monday morning, night, all day Tuesday, and Wednesday morning with a man.

Naked or partly clothed.

I felt powerful.

Not raised on the same bread, me and him, we were not.

He listens to.

I am worried.

That kind of man.

Masculinity is a dangerous place.

All the guns and unchecked insecurity everywhere.

The gaslight fires. The red herrings.

Checking IDs at checkpoints.

Is my desperation making me amorous?

In his absence I oscillate.

A swelling love, a fist for a heart, a float for a walk, always a breath ahead of myself.

That and the pit of being abandoned.

Touch going stale.

Desire overturns the entire ship,

Washed over by the waves, a log on a beach somewhere,

Take the nearest exit.

The trick here is to go back into the theories.

Our bodies kept getting in the way.

A map of salt.

I am restless.

Of love? Of machinery?

Is doubt the true ruler of all things?

The ambivalence, the could-be state.

I am also thinking.

Let them be themselves, give them all the body,

My chest, the open swinging cage.

Let them circle me with tongue hanging out.

For now there is between us salten flesh you have eaten.

Do you come back to me?

Poetry is inventory and prophecy.

It is a name with a whisper inside.

Feeling. Understanding. Affect is not feeling.

There is another knowing of the self beyond knowledge.

It is the silent g in gnosis.

Yesterday we danced.

I don't remember my dreams.

Hello this life. Hello this dream.

Allow the feeling to reign over the fear.

Love has had the longest standing lease on my mind,

I started transcribing my journals.

Look into the mirror of a past self.

If we can go through gnosis through reading,

How can writing, when it is shared, help solve?

Things live buried in pixels and clicks.

I only half learn these lessons I process.

I become a part of my own consumptive input.

I am also sad, a bit, for the other thoughts that didn't make it onto the page—

The years.

For so long, the only part of my brain I tried to touch.

Is there a biological grip on my body?

To convince me that romantic love.

Ideas already deconstructed.

My body is not fluent in this socially evolved feeling.

Just maybe but it is not only that.

Lives in my body somewhere.

Kisses anytime we are alone.

I ran up and down the train car.

It lives among resilient doubt.

Destruction, however, never refused my entry into its voracious mouth.

Inshallah kheir. Kheir inshallah.

There is no room for anything to come in, to go out—I am without need.

Bliss despite the threat of doubt.

So, here we are.

I have a spaceship in my gullet.

The ocean a drop in my gills.

I breathe a broken limousine.

Half for me half for you.

I am the bride of time.

In the sudden speech.

A thimbleful of gardenias at the lip of your mouth.

A horse-drawn sentence arrives.

We are fully dressed.

Our mutual legibility.

I had a dream I was working with youth again.

It could have been laughter.

Despite the wisdom assumed to authority.

Students who have nothing to lose are the Malcolm X's of your classroom.

If guided by justice.

How intuitive their opposition is.

I also.

No one from Dearborn.

Being from Dearborn.

A form of indigeneity.

That thought quickly went away.

The ease and ahistoricity of that claim.

What Whiteness thrives on.

The deceptive ease of the ahistorical.

The urgency to be and know what you.

The rush to claim and have a claim be truth.

The poem of force.

I am now breaking from this to read.

How we perform.

To acknowledge selves within us.

Identity is an event.

The wielding of power as the freedom to be violent.

A history of violence in their bodies.

A nostalgic, generational warmth.

Cozy hot chocolate by a fire—Columbus.

Ice cream on a day of blazing sun—Reagan.

Running free in a field of sunflowers alight—Bashir Gemayel.

Some people feel ancestral warmth toward fascists.

An economy based in scarcity.

Love, acceptance, belonging: limited commodities.

The power granted by citizenship.

I am dissatisfied.

This morning, a fog, a flame.

I am awake.

I am at peace.

There is a small.

After being in a good.

What I am saying is maybe.

Maybe I.

Maybe I will not.

I have rejected solitude.

A future that may never arrive.

Break the windows of my lonely office.

Mind still dewy and unbrined by the day.

Dreams is a holy thing.

I am reminded.

Soldier-warrior.

Is actually a civilian.

White.

In America.

Moving through the world.

No resistance.

Not a finger raised in solidarity with anyone.

Brain numbing couch army.

That shitty fucking American flag.

Circle jerk getting off.

Laziness and ahistoricity.

I wish I could see subversion.

How much work needs to be done.

A, go towards, justice.

Couldn't slow down enough to care.

I was appalled.

How easily one like that moves through our world.

How uncritical one can be of their own perspective.

I took a hit of his weed pen.

I got myself to the Guggenheim.

Hilma.

A grand and gorgeous peace.

Where the infinities live.

Medicine for me.

She would channel spirits.

I feel (malbousa) by a spirit.

Transcription of a primordial breath.

Something is speaking.

Cache of words as tithing.

Calmed my heart and also stoked.

Vulnerability in a way.

She cracks open society and looks at its heart.

What constitutes its feelings.

Guiding me, accompanying me, other women along the way.

Now I'm off to.

It doesn't even cover rent.

Sitting, and scrolling.

Unfeeling, unable to access.

A life ahead.

Dancing and love and joy.

He said he.

I had been misreading.

The bleeding drippy heart I hold to give.

My religious kind of love.

Who knew how vulnerable.

Who watched me give in the darkness.

Who took and stole away.

A scarcity-based model.

Man of the moment.

Only last hope.

The use value of love.

Everyone who needs.

I am tempted to say.

A scarcity-based economy.

People take what is available as if they are stealing.

As if one day no longer.

Men have stolen away with my feelings.

I gave this to you.

There's a responsibility.

To see.

What is there.

What never.

A person.

Emotional analysis and labor.

He works 40 hours a week.

I just lived.

So my body could function.

For work.

How to be in solidarity.

Without judging.

Other people's freedom.

In the capitalist system.

Every puff of a cigarette replacing a thought.

Complacency.

Imagining and envisioning.

A reality that limits.

Language and saying.

This is proof it is possible.

Presence.

Curtail this imagination.

Me in a limited.

As a.

Forces me to reckon with basic truths.

An audience could benefit from seeing.

A world as it can be more free.

He thinks he doesn't need to imagine.

It has already made room for him.

Exist and thrive.

Me feel silenced.

I resist this world.

Instead I find freedom.

Others make and have made.

The Arab Muslim girls I always imagined writing.

They told me they need.

Allegiance is to.

The imagined world.

Makes room for them.

And all their excess.

Firm ground to stand on.

Knowing gives me float right now.

If I am loved.

As a body.

A breakfast.

If he wishes part of me wasn't there.

Amidst all the noise.

See our political.

Love is activism enough.

Don't stand in my way.

Labor.

Does he want?

I have not.

The wherewithal to ask.

I have our equilibrium.

A constrained reality in which to exist.

Recalling.

That journal.

The most catharsis.

A boundary with.

Instead of being obstacles to flourishing.

A truth I am not writing on the page.

Is evolving.

Is evolving.

Is helping me see.

To love an unstable, evolving thing.

A wild thing chooses.

To love.

A testament.

To give in.

Incidents.

How little my American.

"Ummm I feel."

"The book needed more context."

"To really understand."

A disposition of regularized othering.

Anything about the middle east.

The spirit, a center.

A moving propelling.

The culture I was raised.

Constantly under threat in my body.

Intertwined as the events of my life generally are.

Wont to make sense of them.

Disconnected.

It feels I myself will dissociate.

For example.

Tarab.

The beloved as the divine and the lover.

Poetry to.

A container for feeling.

The poet's use.

Tamdeed.

Stretching of word until it sounds like a note.

Like Suheir wrote.

Crooned.

Croons.

Today.

I have been.

Silent panic panic.

What if this is not.

To love mutually.

I feel real as a person.

In life in flight.

Sudden and yet certain.

Blank but infinite.

Fade and yet I.

Instead of fear.

Share with.

What I could.

Ongoing discourse.

Before I met him.

So many things.

Letting him in.

How I can do.

Using this love.

Towards joy and.

A meaningful book.

A book as.

The cover, the title.

A billboard.

A context.

A hand.

A subway.

In transit.

In place.

Set against.

Hands holding.

A palimpsest.

A place in a time.

The age of its technological.

A flat transactional object.

Can also carry a spirit.

Dead or alive.

The dead that do not need to live.

Alive things that never had died.

That refuse.

That resist.

Shrill as alive objects.

Touch, a gilded.

Words stretched.

An aura.

Our origins.

Something about origins.

Keep you company.

This book exists.

Existence is the birth of a transformational thing.

Shrilling in language.

A way of a written.

Yes, indeed this.

And yes, indeed this.

Is a lie.

If some language is.

Maybe all language is.

I want to feel her aura.

[smudged].

A burial for her.

How she may have changed.

The world, my world.

My father, my family.

The village, the trees.

She, that book.

Of herself.

Someone decided she needed to die.

Is not told.

There is a world missing from this world.

I am wondering.

I am remembering.

An aura that piece.

An elegy.

The book in my hands is an aberration.

Our social relations.

The state of communality.

As it is.

Way we relate to.

What the book does.

The electricity there—what is it?

If not a shrilling thing?

The stallion and the.

Night and the rolling sands.

Know me.

As does the sword, the.

Arrowhead, the notebook, and.

The pen.

Almutannabi, the.

Propheted one.

.arabic The

.left to right Read

.archive For

.aura For

.relief comedic for film imam adel from scene Insert

.al7alazona yama Al7alazona

.bnawnaw Alsanawnaw

.morgan ahmad Morgan

.Scene

My ability to pay.

Not here, I am.

Get there today.

Deliberate practice.

Effortless flow.

Being so.

I could have.

Away from myself.

Into his idiom.

Eager to give up autonomy.

Eager to codepend.

Identity, schedule, brainwaves, thoughts.

Make it better.

A part of me.

Confess.

I don't even remember.

No conclusion here.

Documentation of a self.

I'll do that.

When I get home.

I had a dream.

In Detroit and.

I began: sky, people.

Ideas, ancestral.

History of the displaced.

The spirit of.

Hajji walking in the South End.

Looking for her house in Jerusalem.

The train tracks and industrial fumes, playgrounds.

The waters.

There might be no further analysis.

Constellating ideas.

A poem about punishing one body for the criminalized existence of that body.

All other bodies like theirs.

List:

A Brief Introduction to Astronomy in the.

The Book of Fixed Stars.

The Wonders of Creation.

Arab and Arab American Feminisms.

The Last Quatrain of the Ballad of.

Yesterday.

Our lives and the communities.

The 3amos, the surveillance, the gossip, the policing.

Queerness never being an option.

Men totally entitled.

Women accustomed to the lack.

Expecting its lack.

Our misogyny over White misogyny.

My life has already been my life.

I have a hard time.

Imagining the interiority.

In general.

Unimaginable to me that she was a person.

She left this behind.

I woke up.

How about not unraveling.

Journal entry every day?

Away from all of my attachments.

Self is starkly.

Hurling into crisis.

Be as blank as the page.

Displace myself/selves.

Today, be.

Today, do.

A small machine.

The rain fall.

Spring, feel.

You are.

You have been.

Today I woke.

It now, the sun.

At every waking.

Patiently waiting.

Alone. The birds.

Singing doing their sound thing outside my window.

A Saturday peace.

My empty, emptying.

Solitude, how to.

I am thinking.

People in solitary.

My throat.

A queasiness.

A discomfort.

Nothing that warrants.

In process, a lack.

Force upon.

Constantly unraveling and self-weaving humanity.

Policed.

Digressed. It—

Preparing myself for loneliness.

My own apocalypse ahead.

Escape to the stimulation.

Material world.

The phone.

A piece of my brain in it.

Something.

Often trying.

This body worthwhile.

A satellite, a distant star.

Not my sun.

My own sun.

Now to Etel, draw her sun.

Her book.

My lap.

Loneliness, alluvial.

I need a friend.

Yesterday was.

Suddenly it became.

Without my awareness.

Quick, I.

A poem in my dream.

　　　•　　　　•　　•　　　　　　•
　•　　•
This　　　　　　　written　like　This
　　poem　was

you learn to it with the after
 write image

. . . .
. .
. .

read constellation
do right to left
you a

somehow

something sense

makes

This light is.

The birds.

Faintly, far.

A few trees. A dream.

It flooded the lake flooded and the bed.

Water, standing, in water.

I dreamt and my heart.

I was upset.

Being withholding.

A direct transgression.

Not singular static.

And evolves earnestly.

In my dream, the virus.

The virus did not.

My subconscious, the random.

Ephemera, dusty corners.

The confrontation.

I am dealing with now.

The morning lasted til evening.

I never got started.

We were not for each other.

It felt cruel.

Why ruin our present.

With the future?

Blissful experiment.

To just clear.

Instead of cloud.

Despite the attachment.

I am writing.

I am feeling.

I am letting.

Poetry has taught me how to hold.

I am aware.

How frantically we reach.

Codependency.

I retreat.

I am slowly easing.

Living my own.

While also keeping.

My life.

I want.

I want.

I want.

I want.

Occasional.

Let me.

Words are a currency in this economy of feelings.

All the labor behind them.

Sometimes it is a song.

A tune I don't know.

The film atop my brain the veil.

Everything in America a lie.

When we don't talk about.

How does a wrist.

Content without acknowledging.

Gun in its hand.

I call it a flag.

For the light, for ashes.

Elegies for our grandmothers.

Heart is.

A cavernous bomb shelter.

During The Civil War.

It wants to protect you.

The apocalypse, this fiction.

Give me a livable.

Without killing the feelings.

Take me to my grandmother.

The train.

The urgency.

Some days I am.

A sudden pond.

The fish are dead.

The butterflies the.

Looking for that fleeting.

Light I a book.

The wind keeps blowing me open.

It is curious I.

A poet decided.

Leave everything behind.

Big hearted life.

It would be like this.

Bleeding and healing at the same.

Once.

The theory.

Sometimes you gotta let.

A walking home I.

I is a petaled temporary god.

I is dead and alive.

I, a blooming cut.

I carry I carry cut flowers.

Self-portrait as Eve.

That apple taste.

That haram drip.

The cliff of your hungry lip.

I have also been reading.

Traumatizing—the character.

He thinks women.

Evil, love.

He's so afraid.

He keeps women as objects.

All the logics float around patriarchy.

Make it work.

Make men fear.

Since I was a kid.

A college advisor told me.

Eyes pierce the soul.

Told me I was Eve.

Social studies teacher told me I've got it.

Some men look, hungry eyes.

The doctor said.

Men have always taken.

I am made to.

I have been taught.

I am holding too much tension in my body.

Today I.

Too much tension.

To write.

The hole of nothing and.

I considered for a sustained time.

The thought.

Anxiety until today.

My poetry friends group chat.

We go out of our bodies.

The world.

Today I.

We could have.

Instead he.

I can't.

Resistant.

I was fluent not in language.

I was dancing.

Burn but never.

Be consumed.

And also.

The ash.

No scarcity.

Today.

Again my brain.

Looks not at the thing.

What it.

How a single.

Can contain.

A catalogue of expansion.

All is presented as one dimension.

A survival skill.

Detect multiple messages first.

For safety.

What I may say.

Induces the shame.

Upon my whole family.

Do not.

Do not.

Do not.

An American girl.

Do not.

Do not.

Do not.

All at once.

Do not.

What you want.

Do not.

Want.

A video: Seven secrets to make a man.

Feels like a.

Hack love.

I am wary.

Paradigm of capitalist patriarchy.

Invested in this system.

To dismantle it.

Men want to win.

Make him more of a winner.

Calm and happy.

Feel good in the moment.

You're on his side.

Communicate legibly.

Don't emotion.

A man's out hunting.

Single track focus.

His goal of the moment.

Distraction, goal mode.

A great relationship:

Hard to do this if.

You worry.

I woke up and still waking.

I dreamt of.

A different feeling.

To flailing, to falling.

Time, and touch.

A warm body to sate me.

Now, a necessary.

Still when it otherwise.

To feel and to not?

Vulnerable as a woman.

Displaced it onto me.

Comfort is contingent.

The zero-sum game.

At the same time.

Time, the goal.

The world that is boundless.

To run off this feeling.

One beautiful devastating thing.

The slow death.

The earth.

The jellyfish.

The tiny crab.

Believe the water.

The single degree of change.

In the water.

They go towards it.

In faith.

Home and.

It destroys them in the thousands, millions.

At the edge of the earth.

Secrets wash up on shore.

Give a second glance.

Endure.

Another hope annihilated.

Too hopeful, tiny light.

On this earth.

A future, a future.

Anyways.

I release you into spring.

Into god, the unknown.

Cosmic carrier of light.

Hold and sometimes infinite.

I see you, released.

Ancient tremor.

In the bones of my bones.

I do not want to escape myself.

Brings us closer to god. That—

At the expense of my own.

Body's suffering.

I believe in feminine excess, yes.

For those that need an intervention.

A terrorist attack.

[Be dameerhom].

That's fine.

It might.

Teach a lesson.

But so many.

Don't know what to do.

So they discard.

Trauma.

The silencing of excess.

Ignoring.

They did not know what to do.

But they did.

Here I am.

Alive and healing.

X variable is always love, the thing beyond logic.

I had been withholding my own pleasure.

Pleasure only from his pleasure.

The debased woman and the mother-sister figure.

I have not been getting.

Me insecure in a silent.

—and I.

Release for the first time in weeks.

I missed my body, pleasure.

Clarity.

Taught they need sex.

Release

They need, anytime.

Pleasure.

I see how they see.

Bodies.

As objects.

Means to an end (sex).

Body.

Is also.

(baby, love).

Exasperation.

Where once was dread.

My longtime friend.

My longtime friend.

My new friends.

And and and and.

Palestine!

All of us.

Hamdillah.

The awareness.

Highest frequency.

Dedicate life to joy.

Someone is part of that.

To shrill with.

How two can evolve in a mutual path.

Aiming at the cosmos.

What I.

What I.

What I.

The work.

Of loving.

The last time.

I was catatonic.

This time.

I am still being.

I've done it again.

Not love but only its distillation.

A thing that will be satisfied.

God experiencing life through us.

Those are the things that select the life.

The loves that are not scared.

Alone.

How I always.

Am salved, saved.

My Lebanon, for whom my love is always unrequited.

I will always love my country more.

Than you.

This escape route.

Sadness. It is also.

But all this longing.

What it has to say.

How to peacefully exit the room.

Calm its busy restless.

I, I.

Eat please eat.

Poetry when it starts to take over the whole mind.

The world is much, poetry says.

Changed suddenly.

It happened.

It didn't.

—did. Is.

Too—that.

Poetry is spilling over—

Poetry is taking over—

Everywhere, waiting to be transcribed.

Wholeness that comes after a lifetime.

Years of fragmentation.

A sliver of sunlight through a curtain.

Not absolved from feeling.

States of fear creep up and grip.

Despite the fear, find.

again. Inshallah.

Again.

A hunt for the clearing.

Of the self.

And compassion towards.

Men I most feared.

Whose judgment held near.

Whose patriarchy I critiqued.

Existed in.

Wanted approval from.

To be.

In myself.

Hope for an Arab future.

How much I would need to teach them.

To approve of me.

Skills desperately honed.

Specifically for survival.

How to find the inner peace.

Put the self aside while I read.

A text, a person, a conversation.

An avalanche inside my brain.

To deconstruct the dominant narrative.

Armor, to protect.

I never finished the text.

Never saw the whole thing, only part.

Grieve the because.

I experienced, I experienced.

My body.

My own solitudinal.

Void in myself.

The universe's bounties.

Love exists in objects, amulets.

Comfort, the memories.

Attached.

The, the functionality.

The active floating.

In diaspora, away.

Despite.

In spite of.

Beyond both and.

Choosing love instead.

Performance.

The small mode of community.

Belonging that happens.

There, flows.

And by attention, presence.

Like love—

Reciprocity.

Wild, a wilderness.

Feel it again.

Not everyone needs to be rescued by it.

Parts of myself lost at sea.

My horoscope this week.

Hold space for not knowing.

I rarely saw beyond my fear.

Your center wants to find you.

Frantic in a relationship.

All the hopes of the family.

All that nipping at the heels.

Of my desires.

The difference between us is how we read a thing.

The long vast country.

Of self-loathing.

I am still learning.

How to.

Due to.

Marginalization of subject position.

Their perspective doesn't fit.

So.

Imagination.

To make sense.

Nonsensical.

The function.

A feeling, a moment, a history.

Contained in the body.

Must be released.

Ask the art.

For more of itself.

Find.

Small moments.

Concentrated revelation.

To unfold.

How.

Specific my subject position.

To easefully share.

And make space.

For the ones.

Cast out, out.

(The accepted ways of being), procreating, being.

Having, being part.

The social fabric.

Made to feel.

Licentious, gobbling, voracious, hungry, hungered, hungering, devouring.

All of these indelible stains.

To cut us by denying us love.

The woman who.

The woman who.

Any single wrong.

Her to be the excess trimmings of society.

The disposed of.

The one they are not creative enough to defend.

So lodged in their commitment to their privilege.

Cannot see through to the other side.

Of a world.

Of a world.

A system.

This failure to imagine is the failure to feel.

The acceptance of a system that protects only some of its necessary parts.

My imagination has struggled.

Committed myself to the confines of a limited reality.

Found ways to break.

How they should be—how they could be.

Things are a result of philosophies.

I felt it.

In my body.

The work.

Something to feel and understand.

Not love. It is something else.

What exuded.

A temporary momentary.

A taste of it.

His idea. What woman should be.

In this feeling of suspension.

Wanting to preserve my own self.

And pull him closer.

If.

I must want to do the work.

Have hope.

Absurd.

Self-sacrificing.

A continuation of my martyrdom.

Yesterday.

Thinking of that word.

Martyr.

All the sharaf inside me.

Still be honorable.

Dignity and respect.

I needed to seek justice for.

Her.

In the world.

If I couldn't make it happen in the world, I would make it happen in my body.

I decided to perform her.

In the theater of my life.

انا.

لازم بطل ضحي بحالي.

كإنسانة، كإنسان.

ويللي "بيعملو غلط".

بالمجتمع.

هيك.

مش غلط.

هو.

المجتمع اللي غلطان.

هل انا الوحيدة اللي عم؟

عم حاول.

بضميري.

موجود منطق.

التسامح.

الحق.

السلام.

الشيئ الناقص.

يدافع.

عنها.

عنهم.

Arab American feminism creates space for not coming out.

Something about visibility here.

A poetics of change.

What is happening.

As a daughter of [star].

When I am loved.

An Arab.

An Arab.

Struggle.

I pause.

Close to.

Wound.

Raw.

To.

To.

And into.

Work.

It's not on you, it's in you, and what's in you they can't take away.

A place to place.

Love. Community.

A logic to love myself with.

This.

My wound.

He will not have this wound,

Will go on faultless and guiltless.

Rewarded by systems.

Both Arab and American.

That afflicted me.

To see. From.

For they have eaten up Jacob and devoured.

Made his habitation desolate.

Martyrs: Jacob, Mary Magdalene, Ophelia, Alhusayn, Hypatia, Talal Asad's Suicide Bombers, Ego Death.

Note to self.

Holy.

Swimming together in the void.

I should not have believed.

How to forgive and not forget.

The violence of.

And I do forget.

How much.

My body.

This prophesizing work for the future.

A narrative.

Object permanence.

My desires.

Oops.

My brain is responding to the attachment.

It's not.

The future.

Loooooooving.

Again. It hurts. It is a.

A fire I start.

The mloukhiye is cold on the table.

The sheen of salt.

Greediness of love.

Something holy.

A once.

An agnostic tongue.

Anointed.

Goes on to look for false gods.

Free god. See god. What god is.

Only god will keep this secret.

From all the arabic girls who need god.

And believe god lives.

In the body of a man.

And so they go.

Nights looking for holy.

Beelzebub and the false gods that consumed Jacob.

Not seeing the god in her, her blood.

Sin comes.

And leads you.

God is forgiveness for the body.

Experiencing god.

In flesh. And did you.

Your body is the recorder of all things.

Writing out of this suffering and calling it work.

Martyrdom of self and self's access to joy.

Every injustice is evidence.

Connected.

Exit the logic.

To alleviate suffering.

Wanted: someone who knows.

The mysteries.

Within themselves.

So as to not.

Wield them.

Against others unknowingly.

If a gun is held in the hand of.

Who has the power then?

Trick question.

Schrödinger's cat.

Quantum social historical political physics.

See.

Descendant of the.

Buried alive for being.

I have to engage a utopian headspace.

A speculative imaginary.

We have lost.

Our ability to think historically, and by extension.

About a radically different future.

Emergency mode all the time.

Trauma, retrauma.

Never break to think.

Where can we free.

Our own.

Our own.

Poverty.

Colony.

War.

War.

Migration.

War.

Poverty.

Alienation.

Forced assimilation.

Diaspora.

This the honor of a family.

My back—and survival.

Uncouth women were protected.

Before.

Islam, Colonization, Western Hegemony, White Supremacy.

A feeling in the body.

Exists within a feeling in the body.

The real political act.

Utopia exists with a feeling in the body.

The initial revolt always at the wrong moment.

Through being wrong first, the revolutionary subject learns.

What to do next.

Revolting at the wrong time is.

A precondition for successful revolution

Later on.

I woke today wondering.

If a poem could be a slow arrival.

A slow procession.

And if that could be beautiful and valuable in today's.

Landscape too.

Real estate in my mind.

The birds visit my fire escape sometimes.

Nice to be visited.

Calm in a busy.

Be with me.

For a minute.

I woke up feeling.

Lebanon today.

Even the Lebanon of my dreams.

Sometimes that's enough.

The basateen.

The big sky. The fog.

Morning dew in the village.

My grandmother.

My grandfather in the context.

I mostly knew him in American.

It is wild that people get gone.

The thing people talk about, the sustaining force.

Connected to another.

I want to keep being.

A levity. I want.

This levity. I want.

Everything is about.

I feel like I've felt.

Have narrated myself.

I feel an affinity with any being on this earth.

This feeling, to stay.

And not be entirely consumed.

I don't.

I have learned.

These moments require not just armor.

But impetus to ask.

I want and an expectation.

He didn't need to casually.

In order to protect his sense of self.

I am not.

I am not.

I am not.

I am.

I feel I feel.

My body, saintly.

Pious good justified righteous.

Valid serene.

A still pond.

A measured rise.

Fearful in many and facing.

A warrior and also.

An ascetic.

What will words sound like in the future as we come up with new concepts closer to our humanity, our human sociality, de-alienating ourselves?

Influence is tradition.

Prolonged presence.

Of something.

Plus.

The absence.

People don't spend all their time transforming.

Forces transforming us without our consent.

I believe in documenting.

Poetry is a distorted mirror.

Reality is a distorted mirror.

Words is a distorted mirror.

A expansive.

Capacity for.

She.

What.

Technology. A love for the spark.

Alight a room.

To get in the way, design a system.

Stop love and ask.

For its ID card, passport, papers, license.

To live, make love.

Love makes meaning.

Meaning holds onto itself.

Beads of a necklace holding onto the string.

We the beads.

Love. The string.

My love will be traveling in fugitive suitcases called words.

I do the thing again.

The search for poetry.

Is also the search.

Love, the force.

Everything else.

It makes a home for everything.

It is a brick in the house being built around your house.

It makes everything else possible.

I need words.

I keep getting close.

We play house.

I am not sit beit.

I am writing.

I am wanting.

Need for social acceptance.

My body and my feelings.

Then I don't need.

Hopes sometimes are delusions.

Like. What that actually means is.

I need a cat.

I don't want.

Energy of.

Judgments of others. The fears.

Vulnerable.

With my body. My wet.

Others carry.

Take off your shoes.

When you enter my house.

Bad germs everywhere trying to kill us.

And multiply.

Ramadan I am thinking.

My body and my desires, my want.

Of a cigarette.

Or Dunkin' Donuts.

Water, coffee, a bit of weed.

I will not eat.

I want.

This Ramadan.

To wake at dawn.

The Quran or the poets.

The dew of my mind, live.

This life, this body.

A prayer, a supplication.

Not an asking but a saying.

With love I am free.

They (the moments).

Beautiful amidst its rampant.

I woke up.

The emptiness that wakes up with me.

A butterfly appeared.

Maple tree. The blossoming.

Garlands dangling earrings. They.

Heavier with each day of spring.

I am.

Washing the stain.

With my own body.

For the sake of gnosis.

We must remember the martyrs.

Recognize godliness in the.

The string between us.

Silent, taut, and loose.

Your ancience and you.

And there in.

A black hole.

And infinite.

The universe itself.

Everyone a strange host.

Standing guard at palaces of their minds.

Enter, you are lost to the infinite.

And so you run back.

To the arms of your mother.

She, a pelican perched.

A mountain ridge you can trace.

She holds you in her mouth.

Wraps you warm in winter.

My father, the moon.

Knows my heart and gives me his light.

Though he is tired.

The lion.

A center. A.

Galaxy.

Of my own making.

Dearborn marriage Olympics.

The despair of that feeling, to access it.

The surreal. Then so is.

(The logic of my fears.)

Women are made.

Available to them.

Wives given.

As a deserved gift.

We are prepared.

For marriage.

Abound.

Abundant supply of girls to feast on.

Pick your cuisine. Your country.

Pick your body.

Pick your sweetness. Pick your tonic.

Pick your lady. Pick your wife.

The superstructure of the industry of Arab marriage.

Contracts across borders and tribes.

A surveillance structure to conduct preemptive policing inscribed upon the body since birth.

What's new?

They leave when they're uncomfortable.

We live our whole lives uncomfortable.

I craft an object of myself.

A laundry basket. A tapestry. A recipe.
A museum exhibit.

It creates in the world.

Sustains itself. Has its own body.

Like. The sign I taped to the ceiling.

Wake myself up and remind myself I have lived.

It is clear he is.

Something else. I.

We made a small home in the big country.

To which we did not belong.

We cooked. Were citizens of spirit.

We danced.

Lovers whose hearts could burst.

Out of their superfluous skin.

Another's fluent body.

I am old and wise.

Kneaded into the bread of me.

You are young and aging.

Afraid of your own extinction.

A spring chicken in the eternal winter.

Of your racing thoughts.

I woke this morning.

The metallic grief of now.

Instead I started to understand.

My first ten hours of each day

Justifying my own right to exist.

They should not lie about this.

The writer sings.

Can't a thought work?

The theoretical warfare?

Thoughts like chains and walls.

Isolation.

Their thoughts.

Their vulnerabilities.

In the safety of women's.

In general.

A failed experiment in love.

My fear of.

My fear of.

For fear that.

For fear that.

An abjectness.

Arab female.

It lives in our bodies and withers soul away.

I am ready to leave my house now.

I am ready to go outside.

Solitude is a harvest of love.

Isolation is the drought of it.

And continues in the self.

Male dominated science has dehumanized.

Life trying to express itself.

I am developing a case for translation.

That flat objectification.

A woman as.

How it ends.

Our parents give us their questions.

Language belongs to everyone.

All our words glint light.

Some of those lights are fires.

To conquer the world, conquer self.

Conquest is the problem.

There is no domination, there is only knowing and control.

Naked, I make.

Men into monsters.

I peel back my skin, show them my hurt woman.

Ask them what they will do.

They cannot be my heroes with my flesh.

Between their unknowing teeth.

It is distressingly clear.

There are borders between us that feel insurmountable.

All I have is me and these words.

My body is the pulpit from which I preach.

I leave my body to pray.

I would wake every morning and wait.

The structure of things now.

He needed me to be.

Otherwise he could not.

What art is.

Outside capitalist structure.

This is where. The utopian leap.

We don't know what love is for a woman outside of patriarchy.

Leap, imagine, and act accordingly.

My happiness, that temporary.

Some forms of joy are a distraction from a true.

As away as I am, there are ways.

And.

I am afraid to fall into a poem, specifically a feeling.

When I have a lover, I live in elation.

I found a way to not feel degraded.

I marked my body on purpose.

Patriarchal surveillance mechanisms.

The experience of being marked. Like her.

Solidarity in my own way.

Sacrifice. That I could please a man.

His inner demons.

And now I am facing mine.

Society breaks you into conformity for approval.

The realizations are fast.

I hope they live and stay and grow.

I was angry.

I am remembering.

I was silenced.

I would mark my body indelibly.

Someone else, anyone else.

I knew.

Creating the wound in me.

Creates the wound in them too.

Their disposal is not permanent.

They can always come back.

Their bodies are not marked—unless.

My disposal is permanent.

It is death.

Or social.

My body has been marked since birth.

My grandfather gave out money when he thought I was a boy.

He took it back when I was a girl.

My body has been marked.

So I marked it myself.

And what will they do with me now?

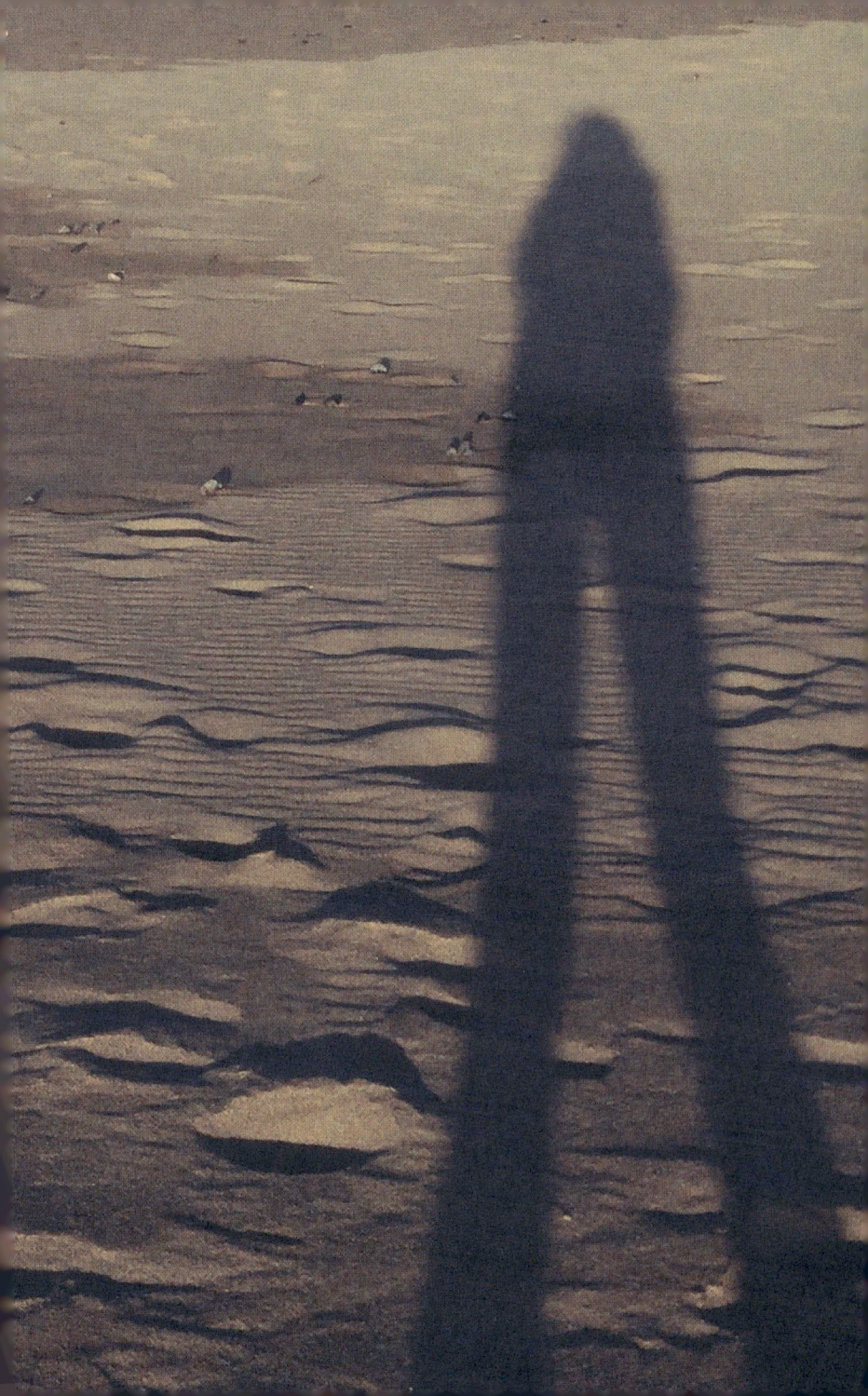

In this book I grapple with a violence
that happened in my family, a violence that accompanied me
as a nebulous, ambient fear seeming to affect every aspect of my life.

This book is an experiment, and so like a god, it asks how to love
the one who is gone, and also the one who is to blame.
and also the situation that created the situation.
In the meantime, as we learn deeper, we say
things toward saying, and so is grief.
This book is an attempt at an elegy,
at carving out a way to say.
To grieve. To redeem.

A book with a hole in it
is composed of fragments selected
from the author's private journals
during a four-month period in 2019.
Excerpts are arranged in order of appearance in the journals.

"The man who is the possessor of force seems
to walk through a non-resistant element;
in the human substance that surrounds him
nothing has the power to interpose,
between the impulse and the act,
the tiny interval that is reflection."

Notes

It might be impossible to locate a text within an exact and discrete constellation of the entirety of its sources, influences, and presences—and something about this inclination does feel a bit proprietary—I am interested in moving away from thinking of language and ideas as property and instead acknowledge the presence of the collective in the work. The collective I've encountered directly or indirectly, as generally and specifically as possible, is ever-present in my work and thinking. I attribute this tendency to growing up in a community that values community.

If it were otherwise, maybe I'd put here a map of the streets I regularly walked during the time I wrote these journal entries or the tree outside my fire escape or the people on the R train, screenshots of FaceTime with my grandmother, group chats with my friends, transcripts of conversations with the girls at the grocery store, images consumed on social media. Much labor goes into the making of a thing, much of it invisible.

How does one list sources for a text originally composed in the act of journaling, of self-documentation, of daily personal processing? In diaristic moments of self-narration, or probably many other functions that happen in the act of journaling, I found myself receiving, grasping for, and hearing echoes of songs, the words of others, advice, memories, wisdoms, other balms, fires, sustenances. From that wet clay of a daily journal's recollections, I began to sculpt.

The language, influence, presence, and present-absence of others are scattered throughout this book, and they are tributaries of my current self, poems, and language. Some of the notes here are paraphrases, quotations, inspirations from, or the direct teachings of others. This list does include a few antipathies, characters I really can't stand, but whose presence I decided should be named, because I want to contribute to defining them in a context. But this list is not at all comprehensive.

I don't trust the proprietary instinct, the claiming of possession. However, I do trust the desire that points me toward honoring sources, community, homage. I trust my desire to give this form. What ensues is an attempt.

Death is finally real. p. 8
Susan Sontag

> This is from Sontag's journals. We read them in the first class I took at New York University. Eager to read Sontag, many of us. In grad school. Reading Sontag. And some of her work is certainly worth reading. *On Photography* changed the way I saw technology and family and time. But then we read that essay or short story on China. Oof. Racist. Orientalist. Her speaker described a massacre of Chinese men with such dangerous object-language. The class got really upset. Later in the semester, or maybe before, I also got upset about Anne Carson's use of the word "moored," and that her speaker after a divorce only wanted to eat white food. Which is to say. That I said that. Then. Sontag. I've always wondered about her essay, "On Digital Photography," which never existed, but I did wonder about it.

The person who is not the possessor of power. Is waiting for knowledge to arrive. p. 9
Simone Weil

> This line is partially taken from, partially paraphrasing, and partially the way my mind held onto a construction from Simone Weil's essay "The Iliad, or The Poem of Force." I am interested in what can constitute knowledge, and what is categorically rejected from being called knowledge. I first came upon this line in Jacqueline Rose's *The Last Resistance*, a psychoanalytic, literary critique of Zionism. It made deep sense. This sentence bears repeating, revisiting, reprinting.

The body of the poet never dies, is immortal. p. 10
Eileen Myles

> In their class on the poet's autobiography, for which I first assembled this book, Eileen gestured at the doorway, stood in it, and said,
>> "Even this is the body of the poet."

He listens to Joe Rogan. p. 23
Joe Rogan

> I debated the inclusion of this name in the book. But there have been and will likely be others like him: hyper-masculine arbiters of popular culture, who enable and empower endemic toxicities. Dangerous demagogues riding libertarian waves of the imperialist, hetero-patriarchal, capitalist, white supremacist

zeitgeist. Voices that tend to stifle the more conscionable, nuanced voices within. Arbiters of personhood. In class, Fred Moten once described someone as seeking to "adjudicate personhood." JR and others like him seem to seek to adjudicate personhood. I don't know. Maybe there's hope for his and others' evolution. Not sure. In the meantime: red flag.

Students who have nothing to lose are the Malcolm X's of your classroom. p. 30
Jeff Duncan Andrade

> This comes from educator and writer Jeff Duncan Andrade who I learned about while working with Allied Media Projects' Detroit Future Schools in 2012 under the guidance of legendary educator Ammerah Saidi.

The poem of force. p. 31
Simone Weil

> Every few years, and sometimes every few months, I go back to this essay. It helps me make sense of the world. I have not, to be clear, yet read Homer's *Iliad*. But Weil's essay does, for now, suffice, and I quote it again, partially on page 171.

Soldier-warrior. p. 34
Simone Weil

> Weil writes that, in *The Iliad*, the "conquering soldier is like a scourge of nature. Possessed by war, he, like the slave, becomes a thing, though his manner of doing so is different—over him too, words are as powerless as over matter itself." The soldier-warrior is one whom force appropriates into its wave. He is many.

I got myself to the Guggenheim. Hilma. p. 35
Hilma af Klint

> In spring of 2019, there was an exhibition at the Guggenheim of the work of Hilma af Klint, considered the first abstract painter in Western tradition. She was a nineteenth-century Swedish artist and mystic whose oeuvre includes gorgeous, hyper-detailed renderings of insects as well as wall-sized channelings of divine messages from ethereal spirits. Being with her paintings felt like a pilgrimage. A practice in trusting oneself, and one's direct connection to the ether. However disjointed it may be.
>
> It all felt very Sufi.

Tamdeed. Stretching of word until it sounds like a note. Like Suheir wrote. p. 44
Suheir Hammad
> This is a reference to Suheir Hammad's poem "bint el neel," a poem which has lived with me for years. The poem begins with her mother listening to Um Kalthoum on a "cheap plastic radio" in Brooklyn. Suheir wrote of Um Kalthoum:
> "you / made mommy cry . . . you loved / poetry and god's word / stressed sang juiced a line / until it rang perfect."
>
> Then later,
> "and now I have made / mama cry i who / love poetry and / god's good word / i who stress a line / until it sounds like a note / *wa into ala bali* / you are on my mind."
>
> The last couplet might be one of my favorite voltas in English, and one of the more formative ones for me. The way Suheir holds a note with those compressed aspirates (*stressed, sang, juiced a line*), continuing into the next couplet about her own words, and then releases us with a sudden song, the volta's portal, the open-mouthed *wa*, which Suheir generously transforms into a plural *ento*, as if Um K is addressing the collective: You are *all* on my mind. Suheir's poems, a balm. Suheir herself a goddess beyond description. I turn you toward her, and to this poem in her book *ZaatarDiva*, and to her other books: *Drops of This Story*; *Born Palestinian, Born Black*; *breaking poems*. Suheir's poems and performance broke the mold of Arab poetry in America, specifically Palestinian poetry, in all the ontological complexities, and her poems shrill across languages, borders, and impossibilities. I, and many others, would not have found home—or rather, a temporary respite—in language, in poems, were it not for Suheir.

A book as. A billboard. p. 47
Morgan Parker
> I was reading Morgan Parker's *Magical Negro* in the New York City subway. For decades, I would feel totally ludicrous, ill, or dysmorphic whenever someone would tell me I was white. But there, in my winter white hands, a brown book, on it written *Magical Negro*. I suddenly could not unsee the whiteness of my skin. The book itself is a brilliant collection proving that fragmented lines gathered in form like sea glass could make of a

poem a transcendent prism, while paying homage to those who came before. A book as an object against objectification. Hallowed object, auratic, alchemical. This book, also, as an object in the world made me feel my racialization as a white-passing person more clearly than I ever had before. In America.

And it did so in a split second in public space.
Though my question now is: And then what?

In the age of its technological p. 47
Walter Benjamin

> This, referring to Walter Benjamin's "The Work of Art in the Age of its Technological Reproduction," which I was rereading then for another project—and accidentally alongside Morgan Parker.

.arabic The p. 53
Marwa Helal

> The arabic is a poetic form Marwa invented.
> It was published in her "Poem to be read from right to left," which first came out in that special issue of *Winter Tangerine* in 2016, guest edited by the poet Xan Philips and titled "Love Letters to Spooks." As soon as the folio was published, I emailed it to my longtime writing group citing the following editor's note from Philips:
>> The aim of "Love Letters to Spooks" was not for non-Black people to gain proximity to Black experiences but for Black folks to have access to themselves free of non-Black projections.
>
> This, I sent to my writing group because being among them is the freest I've ever felt as a person and a writer, and Marwa's poem, and form, embodied that compound freedom and proved something was possible in language. From there, the poetic form of the arabic has been used by many.
>
> This form, it is a righting.

Deliberate practice. Effortless flow. p. 54
Angela Duckworth

> This is from Angela Duckworth's book *Grit*. When I first moved to New York from Detroit and found myself lost amidst folks who woke at dawn to write poems, I audio-booked Duckworth's

Grit out of necessity and on repeat. It helped me understand and establish routines. Duckworth builds on malleable intelligence, famously established by Carol Dweck, who showed us that one's mindset affects how one approaches and succeeds at challenges. Those who believe that one is born predisposed to intelligence possess a fixed mindset, and those who believe that one can grow one's intelligence, a growth mindset. This affects our nations, our households, and the way we live our daily lives. After hungrily listening to this, I deepened my practices in time management and routine, which became essential to my life as a graduate student and writer. I designed structures and practices that reflected my priorities, from which I ebb and flow. From Duckworth, I learned that to get good at something, one needs to engage in deliberate practice and also give themselves time to effortlessly flow.

A List: p. 57

The full reading list here is:
The Book of Fixed Stars, Abd al-Rahman al-Sufi.
The Wonders of Creation, al-Qazwini.
Arab and Arab American Feminisms, edited by Rabab Abdulhadi, Evelyn Alsultany, and Nadine Naber.
"The Last Quatrain of the Ballad of Emmett Till," Gwendolyn Brooks.
Names are not weightless. Not just words but incantations.
They mean the most real
beings we know: people.
There is a hole in it.

Now to Etel. To draw her sun. p. 62
Etel Adnan

In the most pivotal moments of recent years, I've turned to work by Etel Adnan. I have found kinship, comfort, and necessary difficulties in her language, subject, and form. In this poem, I turn to the sun in her paintings and her writing; hers is neither solely a benevolent nor a menacing sun, but rather a shifting entity across all of the above. The manyness of the sun is one of the few certainties I turn to often.

The shape of this book came from a possibility I learned through Etel Adnan's more ambient, book-length texts; specifically her *Sea and Fog*, and later, *Premonition*. *Sea and Fog* felt like a safe space

for me to live in. I felt that each line to come would keep a peace, even if it mentioned a violence. There was something endlessly and recursively beautiful about this form, about lines like waves lapping onto a shore.

I was first turned toward Etel by a few writers I met in 2015. First was Ben Ehrenreich, who told me about *Sitt Marie Rose*, and then Sarah Riggs and Omar Berrada, who told me about *The Arab Apocalypse*, Etel's work at large, and Jalal Toufic. The hole in this book is deeply informed by Jalal Toufic's formulation of the surpassing disaster. There is certainly a too-much-ness to all of this that I cannot erase. It does spill over. When I needed a developmental editor for this book, a whisper in my ear asked for Omar; he graciously accepted to help me revise the poem, surprised by how his and Sarah's passing recommendation proliferated in my life.

Enti mish na2sek shi. between p. 74-75
Tata Sitti Um Hafez

> Missing from these pages but deep in them is advice from my maternal grandmother, with whom I've always felt a deep conection. One day, Sitti Um Hafez grabbed me by my shoulders. Looked me in the eye. Asserted, "inti mish na2sek shi." At that time, I was sick and couch-bound for two weeks with a virus the doctors couldn't explain. (Their remedy? Tylenol.) We never even considered it could be airborne or contagious. But that shit tried to kill me, I swear. It surfaced my insecurities. Somehow, she knew, my grandmother. She told me, there, her hands on my shoulders,
> "You are not lacking in any thing."

Ya khsara. between p. 74-75
Warda

> Also in these pages, I come to mention this song by Warda, the Algerian diva. It is titled "Ya Khsara," as in "Oh, what a loss." Sarcastic or serious. Anytime, one can say this. Ya khsara. The song appears on her 1992 album *Batwanes Beek*. Of course, the titular song is the more famous, ecstatic one, fit for dancing, but "Ya Khsara" is the most utile. Great for fairweather friends, performative allies, rejections, and breakups.

I have also been reading. p. 77
Bertolt Brecht
>Brecht's play *Baal* was on a class syllabus, but then was removed. I still read it. The main character was so misogynistic, it made me physically sick.

It might. Like Myriam Klink. Teach a lesson. p. 88
Myriam Klink
>Omitted in the main text here is the mention of Myriam Klink, a Lebanese Serbian genre-flailing figure (yes, in the Lauren Berlant sense), a model, pop star, talk show guest, animal rights activist, and ultimately, in my opinion, performance artist. Klink is often clad in pink and plastic surgery arguing for moderately incendiary opinions, and her interiority is regularly dismissed by people who cast eyes on her person. My friend Abbas said that Mariam Klink is one of the ninety-nine names of Allah. In grad school, I wrote a paper describing Mariam Klink as a post-Arab spring, camp, pseudo-revolutionary, with guerrilla politics in hot pink high heels. But Klink is no outright revolutionary. I recall one specifically racist post on social media recently, which her latest music video espousing racist ideas about coronavirus confirmed. In the public stage that is Lebanon's TV talk show circuit, she once reigned as a dissenter. A former model turned minor pop star, her songs critique rampant governmental corruption and the men who have wronged her or have yet to.
>
>In an endless sea of Arabic pop songs' declarations of undying love, Klink offers a satisfying alternative. Tfeh, she says about a good-looking man she's not interested in. Nya22, she creaks. To2 moot, she says: go burst and die. And she does this in a rotating wardrobe of head-to-toe pink getups, all while claiming to be a virgin and donning a Kalashnikov. She's also a miracle of science: rumored to be in her fifties, she and her doctors have crafted an appearance that thwarts age. While often scoffed at as a joke, Klink's contribution to the visual, sonic, and affective palette of the Arab world is not to be dismissed, and even reveals how our own desire for a respectability politic is greater than our urgency for a cacophony of voices in political dissent. Mostly, she reveals our visceral inability to actually hear and witness what sexualized women are saying. A Spivakified (forgive me):
>>The sharmouta cannot speak.

The "our" here is not an attempt to speak on behalf of the people of Lebanon, where I have never lived. Rather, the "our" is one that is too well-aware of its placement in diaspora. Always at a distance. Nonetheless, it's a "we" that invites others to join at their will. In 2016, Myriam Klink was also the recipient of one MP's write-in vote for president, a role before and thereafter held by a war criminal.

The debased woman and the mother-sister figure. p. 90
Sigmund Freud

> The one relationship this book coincides with entailed dozens of breakups (yes, with the same person). However, it was the first of those breakups that prompted me to leave behind my copy of *The Freud Reader* for my then (and then and then and then and now) ex. Specifically, I flagged for him the essay "On the Universal Tendency to Debasement in the Sphere of Love," in which Freud writes of men still stuck in the regressive stages of the virgin-whore complex:
>
> "Where they love they do not desire and where they desire they cannot love."

My longtime friend. My new friends. p. 92

> Here were listed some dear friends: Sirene, Dima, Adnan, Rami, Peach, Bernard, Janelle, and Jenna. Specifically, this litany ends with: Jenna! Palestine!

It's not on you, it's in you, and what's in you they can't take away. p. 114
Nipsey Hussle

> During the time in which I wrote these journals, Nipsey Hussle died. It was 2019, March 31. I started looking him up and watching videos of him. Struck by his community work and his mindset, I was moved to keep his words in my notes, to remember how to be.

For they have eaten up Jacob and devoured. Made his habitation desolate. p. 116
Jeremiah 11:10

> During my MFA, I audited a Bible class, due to my lack of exposure to religious stories growing up. It felt a bit like reading the fine print of society. My focus was distracted with other things though. Like housing insecurity, money, emotional stability,

romantic partnership. Despite that, I learned some essential narratives: Jeremiah, Cain, Abel, Eve, Jacob. The Bible as an anthology compiled from different sources across time. Among others. Ecclesiastes. That snake.

Loooooooving p. 118
Birhan Keskin

In Eileen Myles's class, we were assigned to read *Y'ol* by Birhan Keskin, a Turkish lesbian poet, translated by Murat Nemet-Nejat. Her work, for me, enacted a poetics of tarab, of the ecstatic. Like what Suheir wrote: she stretched a word "until it [sounded] like a note." Keskin's poems in translation put tamdeed, the prolonging of a syllable or word, to English. My fellow American poets were not as pleased with it as I was. They called it "sentimental." Mooooooooooooooon. Looooooooooving.

We have lost. Our ability to think historically, and by extension. About a radically different future. p. 122
Fredric Jameson

I was assigned to read Jameson in Professor Barrett Watten's grad class at Wayne State University. For better or worse, I didn't absorb much of the text. But I kept going back to this excerpt. Somehow it stuck, became useful. Panic reading in grad school sometimes gives you a line, and for that line, I am grateful.

The real political act. Utopia exists with a feeling in the body. p. 124
Slavoj Žižek

The Žižek quote came to me in conversation with a friend in Detroit. Probably over drinks somewhere after class, if it's the night I'm thinking of. The conversation probably started with some kind of complaint, but I was obsessed with theories about utopia at that time, within or in relation to existing structures of power. My colleague recommended a reading from Žižek. I wasn't expecting to quote Žižek in my first book, but here I am. This is what I have left of that night and that conversation. I put it in my notes and kept going back to it.

The initial revolt always takes place at the wrong moment. It is only through being wrong first that the revolutionary subject learns what to do next. Revolting at the wrong time is a precondition for a successful revolution later on. p. 124
Rosa Luxembourg

>I have no idea how I came across this Rosa Luxembourg excerpt. I'm not even sure if its by her verbatim. But I think about it often, and recall it in my journals. Since then, I'm looking for the premature revolution, that got there early on accident.
>
>This is a little reminder for all the arabic girls, I guess. Which is to say, all the girls who have reason to revolt. And by girls, I mean the universal.

A measured rise. p. 130
Robert Hayden

>Robert Hayden's poem "The Diver" was first taught to me by Professor Laval Todd Duncan at Wayne State University, who has taught Black poetry through the decades. He is a vault of history, a generous and brilliant champion of poets.
>
>Hayden's "The Diver" is one of my favorite poems of all time. It taught me what a line break can do. And also, what it means to enter the difficult place of a poem.
>This poem, for me, is a portal.
>
>There's also a line referencing Hayden on page 30. I cannot say lonely office without thinking of him, or his father, or love.

It is a brick in the house being built around your house. p. 133
Cornelius Eady

>Jamaal May, who was a friend before he was ever my professor, who I met on a Megabus, some kinda magical poetry kinda stuff, whose poems make magic—like the one about Zombie Jesus at a barbecue or the children and birds in Detroit or the Zug Island hum. In class one day at Wayne State, Jamaal recited this line from Cornelius Eady's poem titled "Gratitude." It feels like what some people are doing with language: building homes in language in which to live, self-see, thrive. Then the grace of sharing art, where others can make themselves too.
>
>Whether we are aware of it or not, language contains us.

Our parents give us their questions. p. 148
Valeria Luiselli
> This, among the many haunting, haunted lines in Luiselli's book, *Tell Me How it Ends*, written about her time as an interpreter for children who fled their home countries, mostly in South and Central America, who came to the US carrying all they had, were labeled "undocumented" as such and then. And still .
> There is a hole in it.
>
> The morning of this revision, a woman on the news was speaking, who was captured and detained by the United States of America, where they chained her for three hours, then forcibly gave her an injection.
> There is a hole in it.

What art is. Outside of a capitalist structure. p. 151
Foucault and Chomsky on YouTube
> As one does, I wash dishes while watching debates and lectures on YouTube. In 1971, Foucault and Chomsky debated human nature on Dutch television, and someone put it online. What remained of that discussion was this impossible question. In the original debate, Foucault probably called it bourgeois structure, not capitalist structure. And he wasn't talking about art, but rather human nature in general, though they spent a lot of time talking about creativity, and freedom, and sometimes specifically about art. This debate is so dense; every time I watch it, I get something new. But the question appearing in the text here crystallized for me during a mid-journal memory of my experience watch-washing to this debate. I'm grateful it exists. Baba says Chomsky has always been a friend of Palestine. The last thing my Khalo sent me on WhatsApp before he died was a Chomsky interview about Palestine on YouTube in the early days of the pandemic. I guess we are a people that likes watching Chomsky on YouTube. Neither Baba nor Khalo ever told me anything about Foucault. But there's trouble in Chomsky too. A friend of Palestine, but not a complete friend of the Syrian revolution. A friend of Palestine, but not a complete friend of the *B* in the Boycott, Divest, and Sanction movement. I am told about this trouble by my former professor, now friend, the dearest Anton Shammas (who himself wrote an ontologically impossible narrative into a language, who himself would have likely edited out this note, as he half-jokingly advised I do with this whole section).

It is death. Or social. p. 153
Orlando Patterson

>Originally, this was written: It is death, or social death. Somehow social death found its way into my vocabulary years before I'd ever even know where it came from. Or maybe I was once told where it came from, but it did not register, or hold, or continue to be contained. Sometimes, America gives you an entitlement that makes you think anything you encounter can be for your use. There is a hole in it.
>
>As far as I know, "social death" is a term coined by Orlando Patterson, who conducted the first contemporary comprehensive study of slavery, titled *Slavery and Social Death*, in 1982. A tome. An almanac. Across time and space and "civilization" and concept. For some, the book is outdated. Social death names a process within enslavement in which a person is uprooted, depersonalized, de-socialized from the society in which they were born, which Patterson calls natal alienation, and then the person enslaved is introduced into the master's world as a nonbeing, who possesses an original, indelible defect.
>
>I am still processing this information in my study. I didn't know, when I was writing these journals and thinking about "social death" (also thinking of Mbembe's "living dead") that I was using a term coined in reference to slavery. There are slaveries in our present. See: Kafala system in Lebanon and elsewhere. Prison labor in the US. The un-reparated descendants of the enslaved. Imperialism. The wake. There is a hole in it. In my context, I feel resistance and impossibility in the space between the self and social death. Impossible because slavery cannot sustain the superfluous and succubic burden of being a metaphor. As slavery itself, and our ongoing contemporary moment, makes of human, metaphor. I kept these lines because I want to tell the truth about the journals. About what was first felt. So we can look at it. At what became a part of a constellation.
>
>Though far from its origins.
>
>It makes me wonder, if at all,
>who or what
>is universal.

Photograph p 156-63
Oxnard, California
> At the beach, on an autumn day, the tide kept coming and
> leaving behind what looked like tiny, sparkling holes across the
> shore. Coming closer, I saw the sand was covered in tiny blue
> jellyfish—protozoa actually—called *Vellela vellela* jellyfish, or
> by-the-wind sailors. They washed onto the shore because of global
> warming, misguided to an untimely death by the one degree of
> change in the sea's temperature.
> I felt grief. The afternoon a big funeral.
> That same summer, I saw tiny red crab
> shored up en masse at Laguna Beach.

Photograph p. 164-65
The Daily Mail
> I found these photographs of La Push, Washington online.
> The protozoan massacre extended up the coast.
> This article was titled: "No room for a beach towel!
> BILLIONS of mysterious jelly-fish-like creatures
> wash up on beaches along the west coast of the U.S."

Photograph p. 166
Oxnard, California
> I keep remembering their fins flapping in the air. It looked like
> they were breathing.
> I wonder how many of us go toward what will kill us.
> If not our bodies, then our spirits.
> What belabors breath.

Photograph p. 167
Oxnard, California
> And there I was.

Acknowledgments

It takes a lot of people to make me, and this book, possible.
I wouldn't have it any other way, except to have more ease and love for all.
May saying this make way for the better.

Thank you:

> *to my people who see me, feed me, free me, dance with me, who sublimate panic and pain into patience and power.*
>
> *to everyone who compelled my compass in a direction I could move along, towards, away, with; to all with whom I have been in relation, which is a divine grace (presence) however we carry it / however it carries us.*
>
> *to my family, who keep love and conversation at center, who talk and try with me toward a world and a way where all live with the dignity to be free, to evolve.*
>
> *to my friends who are my friends; who keep my spirit spirited; whose care and presence is transformative; whose being and joy is part of what makes it all livable, even when it is not, it is.*
>
> *to everyone in my creative and political communities who has made new and necessary sayings possible and inevitable; who dared to make and share; who make space and make way in form, content, beholding, action toward all this labor's eventual destination: "the (collective) heart."*
>
> *to my teachers who shared their words, wisdoms, precedents, precisions, attentions; who showed me vital tools (trick, heuristic, theory, sound, dismantling, analysis, invention, secret) for languaging.*
>
> *to all whose works and presences I experienced in the process of preparing this book; for making, and sharing, and adding to the tensility of the world, to the repertoire of tone, metronome, possibility, possibility of form, essence, story.*
>
> *to the music makers, for the dances and dissonances and peace and release and paradigm you provide—especially makers of Detroit house, wire recording music, electro/shaabi, and tarab of all kinds.*

to my editors, who, with respect, talent, and gentleness—clarify, sharpen, and amplify. with an unimaginable patience and generosity, you gave me and my words kindness and time.

to all at my publisher, for selecting this manuscript that long felt impossible; for your patience, labor, and care for this book; for working with me to honor the present-absences of those we love.

to my communities at home, with whom I am always in communion, to whom I am always in service, you'll all—you'll all—you'll all—you'll always be in my dreams; may we always arc closer to love.

to all who struggle toward decolonization, abolition, liberation, healing, and transformative justice here, elsewhere, known, unknown; your praxis holds the ways; I hope to be useful; I wish you joy.

to those who recognized my need for material support and honored me with it, giving me the means to live while I completed this book

to my cousins, whose joy and love is healing, who carry our shared and complicated histories in ways as numerous as we are.

to my khaltos and khalos, whose respect for my autonomy never wavered and sets the standard; my first and forever radical utopia is with you, talking, healing, dancing.

to my amtos and amos, whose feeling of love is so big, it spans continents and makes galaxies; I hope we are forever in understanding and conversation; thank you for this village kind of love.

to my brothers, who teach me perseverance and vulnerability; who are each a vessel for the divine, who are brilliant and kind; there is no end to any sentence I write for you, to you; we go on, habaybi—

to my sister, my metaphysical proximate; ever-present guiding light; okhti okhti; without you, there is no way; with you—hamdillah

to mama, to whom my compass points; whose joy makes more joy; who taught me the word feminist; whose depths are endless—

to baba, who first pointed my compass toward justice; who is a bottomless well of love; baba, alrafiq.

to my grandparents: tata, my friend, her dignity and strength; jido, kind, steadfast, generous king; sitti, my namesake, her resilience and beauty; jidde "el erhabi," whose fight I must have inherited.

to the sun, the moon, the rivers, the animal friends, and plants who wave their hellos, to the land, and Jupiter whose bright light is with us these days.

to my sister-warriors, who keep the flame alight in perpetuity, who take turns to rest; whose communion and courage and love and friendship and presence loves life, gives life, makes good life inevitable.

to my chosen family, it is one of my greatest gifts to hold you and be held by you, and to learn to do it better, across time and space.

to all I have failed to inscribe here, I hope my gratitude reaches you nonetheless.

to those who commune with me who I do not yet know.

to you, reading this.

to the stars, in darkness, light.

A book with a hole in it
© 2022 Kamelya Omayma Youssef

All rights reserved. No part of this book may be used or reproduced without prior permission of the publisher.

Passage Series #5
First Edition, 2022
Second Edition, 2025
Edition of 500 copies
ISBN: 978-1-7359242-9-8
LCCN: 2022946730

Edited by Corinne Butta
Proofread by Juwon Jun
Designed by Rissa Hochberger
Back cover type design by
Lara Atallah via Everybody Press
Typeset in Garamond 3 LT Std, Times New Roman, and Caslon Five Forty
Printed at Jelgavas Tipogrāfija, Latvia

Images:
pp. 156–62, 166–67 courtesy the author.
pp. 164–65 courtesy the National Oceanic Atmospheric Administration.

Special thanks to Omar Berrada and Courtney Carliss Young.

Published by Wendy's Subway
379 Bushwick Avenue
Brooklyn, NY 11206
wendyssubway.com

Wendy's Subway is a non-profit reading room, writing space, and independent publisher located in Brooklyn.

The Passage Series features titles by emerging writers and artists whose work manifests in innovative, hybrid, and cross-genre forms that imagine new possibilities and expressions of the poetic, the political, and the social.

A book with a hole in it was selected for the 2020 Carolyn Bush Award.

A book with a hole in it received the 2024 George Ellenbogen Poetry Award, presented by the Arab American National Museum's Book Awards.

The Passage Series is supported, in part, by the New York State Council on the Arts with support of the Office of the Governor and the New York State Legislature; public funds from the New York City Department of Cultural Affairs in Partnership with the City Council; and the Robert Rauschenberg Foundation.

It is so refreshing to encounter a first book as daring, original as Kamelya Omayma Youssef's *A book with a hole in it*. Youssef's poems are formally supple enough to slip from visual dream poems into odic dialogues with titans like Simone Weil, Etel Adnan, and Walter Benjamin. Radical enough to assert, "I am here to enjoy my joy;" to shout and praise, plainly: "And and and and. Palestine! All of us. Hamdillah." I'm such a grateful student of this work.
—Kaveh Akbar

What is love for a woman outside of patriarchy? What is life for an Arab outside of white supremacy? Kamelya Omayma Youssef's poetry surveils all that stands in the way of liberation and offers a challenge and a manifesto at once. "Leap, imagine, and act accordingly," she entreats. And what wondrous liberation that way lies. Here is a brave voice, guiding and mesmerizing in its vulnerability and power. Listen and leap!
—Mona Eltahawy

A book with a hole in it is reading as good as thinking. Lines stop cause they're too full, don't want to say any more, and even in silence the interior is just bursting, the book is so rich. It leads out, proudly, though it pauses first.
—Eileen Myles

This beguiling, genre-resistant book of fragments is a black hole of beauty, in which Kamelya Omayma Youssef ever so gently reveals to us, among other things, how to make language tell a painful story that can never be told. The Arabic of her unconscious glimmers so enchantingly through the lines, and not only from right to left, taking us way beyond the periods, to the wondrous spaces where she alone can go.
—Anton Shammas